Preface

Since the dawn of civilization, the idea of body decoration has always stimulated the imagination and given rise to many different designs. From the earliest kind of body painting, done with colored powders made from mineral and vegetable matter, to tattoos, scarification and other types of skin ornamentation, the human body has continued to be altered and embellished in the never-ending quest for perfection. Echoing this past that is distant and yet near, body decoration has today become fashionable again. It is enriched by elements borrowed from other cultures. In that aspect, it reflects a new awareness of our world. The enormous lexicon of skin decoration takes its images from such diverse subjects as calligraphy, mythology and the graphic arts, and its nourishment from the poetic language of humankind's symbols.

The designs for skin decoration that follow have nothing to do with the concept of permanent tattoos; in fact, they offer an infinite scope. Fleeting and painless to apply, they are first and foremost ornamental. Light and fanciful, they help to liberate our body images from old-fashioned conformity. And yet these decorations are not entirely superficial. As motifs, each has a symbolic message, be it sentimental or idealistic or intellectual. Each design has something to say. In so doing, these are expressions of impermanence that also celebrate the magical beauty of the moment.

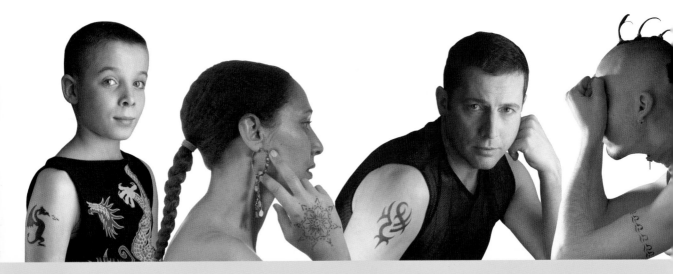

Contents

T E M P O R A R Y T A T T O O S

THEME : Nature

Level of Difficulty: ☆ easy ☆☆ not so easy ☆☆☆ challenging

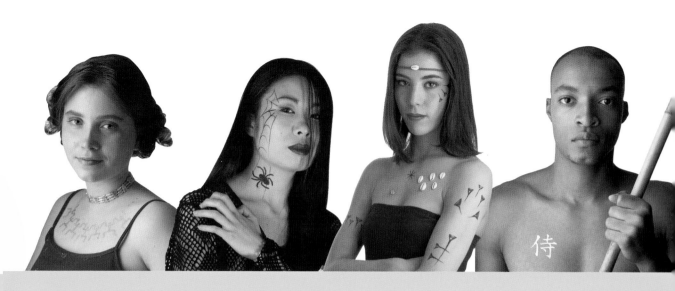

Your Skin and Temporary Tattoos

Today's cosmetic preparations make it possible to decorate all skin shades. A wonderful palette of colors is available in waterproof body liners. As a general rule, use colors that contrast with the shade of your skin so that the tattoos really stand out. With fair skin, use dark colors; bright colors and those with iridescence look best on golden or olive skin; with black skin, choose light, iridescent colors, even those with metallic effect.

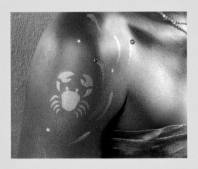 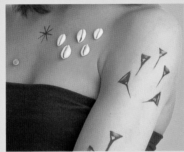 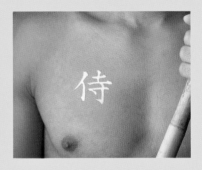

PREPARATION

No matter what products you are using to apply temporary tattoos, start with clean skin for best results. Sponge the area of application with a cotton pad dampened with rubbing alcohol; this will remove any residue of natural oils, perspiration and lotions. It *is* possible to apply a temporary tattoo over makeup, but it will not adhere as well or look quite as effective. And it will be gone when the makeup is removed. Still, removable tattoos, like makeup, should be regarded as transitory enhancements to be renewed or reapplied regularly as part of one's personal routine. For designs that are applied to the face, we advise you to use preparations that are soap-and-water soluble. It should go without saying that only cosmetic products should be used for these applications, particularly on the face, to avoid any chance of allergic reactions.

DURATION

In general, temporary tattoos last from one to three days. Their lasting quality depends upon the following factors:
- Is the tattoo applied in an area that clothing may rub against?
- What is the quality and condition of the product being used? A bottle of body liner fluid that has been left open will soon deteriorate.
- Finally, we must consider the texture of the skin itself and be aware that the outer layer is constantly regenerating itself. Any solution applied to our skin will vanish sooner or later, especially when combined with perspiration.

Keep all these things in mind when applying a temporary tattoo.

POSITIONING SKIN DECORATIONS

In this book, we show decorations on different parts of the body so you can visualize how these will look on your shoulder, your arm or your chest, for example. Above all else, temporary tattoos are about glamor—even seduction—and are used in the spirit of fun and fantasy. Always taking into consideration your style of clothing and your own tastes, you personally will be the best judge of where to apply these decorations on any given occasion.

Temporary Tattoos

Erick Aveline
Joyce Chargueraud

FIREFLY BOOKS

A FIREFLY BOOK

Published by Firefly Books Ltd. 2001

First Printing 2001

**U.S. Cataloging-in-Publication Data
(Library of Congress Standards)**

Chargueraud, Joyce.
 Temporary tattoos / Joyce Chargueraud
and Erick Aveline. –1st ed.
[64] p.: col. ill.; cm.
Summary: Temporary tattoo designs and techniques.
ISBN 1-55209-601-7 (paper)
ISBN 1-55209-609-2 (bound)
1. Body painting. 2. Body marking. I. Aveline, Erick. II. Title.
391.65 21 2001

Published in the United States in 2001 by
Firefly Books (U.S.) Inc.
P.O. Box 1338, Ellicott Station
Buffalo, New York, 14205

National Library of Canada Cataloguing in Publication Data

Chargueraud, Joyce
 Temporary tattoos

ISBN 1-55209-601-7 (pbk.)

1. Body painting – Juvenile literature. 2. Tattooing – Juvenile
literature.
I. Aveline, Erick. II. Title.

GT2345.C42 2001 j391.6'5 C2001-930722-5

Published in Canada in 2001 by
Firefly Books Ltd.
3680 Victoria Park Avenue
Willowdale, Ontario M2H 3K1

Graphic design and layout: Christine Dufaut
Photography: Charlie Abad
Editor: Youna Duhamel
Editorial Director: Catherine Franck
Technical Coordination: Nicolas Perrier
Photo-engraving: Nord Compo
Translation: Frances Hanna

Printed and bound in Canada by Friesens, Altona, Manitoba

Acknowledgments

The authors wish to thank all those who participated in
the creation of this book, including Make Up For Ever,
5, rue de la Boétie, 75008 Paris, France.

This book also owes a lot to its models, and we thank
them for their enthusiastic participation: Jessie Booth (Leaf
Bracelet); Kenan Chargueraud (Dragon); Yannick Cochard
(Unicorn); Eva Delangle (Chinese Ideogram, Hindu Motif);
Marieke Delangle (Egyptian Cartouche, Prayer Necklace);
Terry Desfontaines (Japanese Character); Michel Dubois
(Tribal Motif); Katell Gallon (Sun, Sumerian Cuneiform
Designs); Julie Ildefonse (Paradise Island, Witch); Fumi
Johnson (Zodiac Sign of Cancer); Nacira Menadi (Star of
Maghreb, Toltec Footprint); Brice Pinta (Indonesian Spiral);
Erwan Simon (Tree of Life, Bat); Christine Van Ngoc Ty
(Spider's Spell). Thanks to Charlie Abad for his valuable
contribution. Finally, we very much appreciate the
sound and sensitive advice of Catherine Franck and
Youna Duhamel.

Please share your ideas:
Erick Aveline
2, rue des Côtes
78600 Maisons-Laffitte, France

Cosmetic Products and Accessories

Products to be used for temporary tattoos are longer lasting than standard cosmetic preparations. They dry faster, do not stain clothing, but can be removed with soap and water. Do note that products with a mineral or vegetable base (such as henna), traditionally used to dye the skin, have no place in this book. Several brands offer skin-liner kits, sold in little bottles with applicator brushes. The most popular colors are red ocher, maroon, green, blue, black, and also white.

For this book we used:

1 Waterproof body liners in a range of shades, with matte, iridescent and metallic finishes

2 A commercial stamp and three inking pads (for the Tree of Life design)

3 White mehndi stick or foundation cream (base) to create the Japanese character on dark skin

4 Liquid watercolors made for skin (for the Paradise Island design)

Skin Ornaments

5 Shells, pebbles and bindis can be applied with eyelash adhesive and removed without a solvent. (Some people are allergic to latex and may have a reaction to the latex base of eyelash adhesive.)

Tools and Accessories

6 Liners are applied with an artist's fine paintbrush or an eyeliner brush

7 For the cuneiform calligraphy designs, a chisel brush is used

8 Where called for, use soft makeup sponges

9 A makeup pencil is useful to outline a design

10 An orange stick (used for manicures) is useful for applying the glue to skin ornaments

11 Use tweezers to pick up and to apply skin ornaments

12 Hologram embossing powder

13 Iridescent body gels

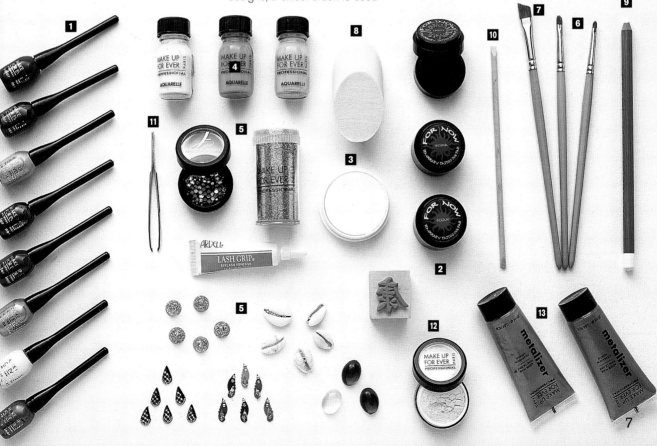

Materials

The simple list below is in keeping with the concept of this book—to create stunning graphics in an easy way. You should enjoy creating temporary tattoos with a minimum of tools.

1 Foam-board, ⅜ inch (1 cm) thick, for making the stamps

2 X-acto knife, a precision tool for cutting foam-board and stencils

3 Sheet of adhesive acetate for making stencils

4 Sheet of white cardboard or Bristol board

5 Tracing paper for copying designs to be painted on the skin

6 Soft lead pencil (B or 2B)

7 Transparent tape to hold stencils firmly on the skin (a hypoallergenic clear first aid tape is ideal)

8 Adhesive tape to hold the designs in place for cutting stencils

9 Waterproof paper glue

10 Cotton swabs for applying glue

11 Tweezers for picking up and applying skin ornaments; also used with stamps

12 Sharp paper-scissors

13 Rubbing alcohol

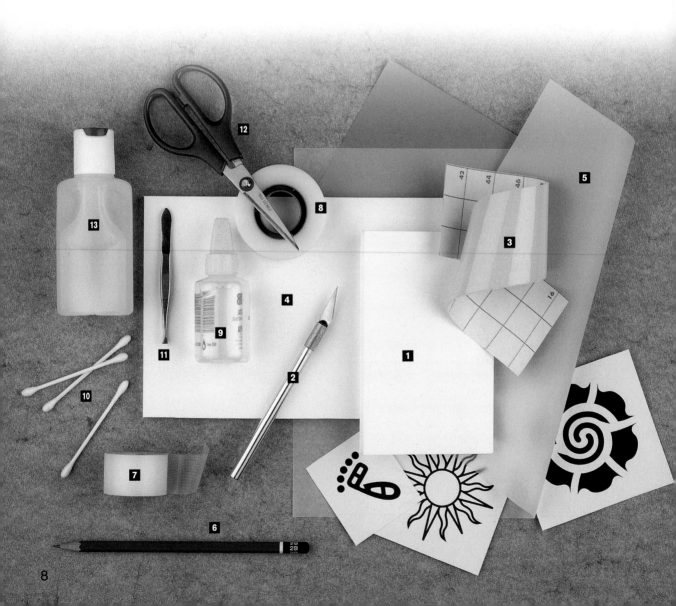

Making a Stamp

This technique takes a little time, but once the stamp is made, you can use it several times. Remember that the design you cut into the foam-board will be reversed when the stamp is applied to the skin. (Compare the stamp below with the design on page 28.)

1 Using the cotton swab, apply a thin, even film of glue to the surface of the foam-board and then affix the design; let it dry.

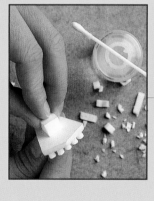

3 Peel the cardboard surface from around the design. Using the blade, make a slit around the edge that goes about halfway through the foam-board. Carefully remove any excess material from around the design.

2 Make a cut in the foam-board about ⅛ inch (3 mm) from the edge of the design, and then cut around the motif leaving a narrow border. The knife blade should be perpendicular to the surface of the foam-board and should penetrate about half its thickness.

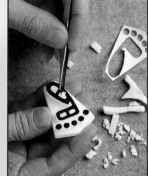

SUPPLIES
- drawing or photocopy of the design
- ⅜ inch (1 cm) thick foam-board
- waterproof paper glue
- X-acto knife
- cotton swab
- tweezers

5 Cut a small cube of foam-board about ⅜ inch (1 cm) square and glue it to the back of the stamp (to make a small handle).

4 Use tweezers to remove the excess foam material from inside the design.

Making a Design with an Artist's Paintbrush

There are two ways of proceeding. You may want to paint the design directly onto your model's skin. This will mean that you can adapt the design or its size, depending on the desired effect. But you may find it easier to copy or trace the design onto tracing paper, then transfer it to the skin. We show you the latter method below.

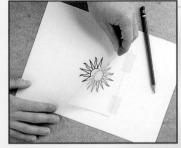

2 Once the tracing is complete, if it is directly applied to the skin, it will produce a reverse image to that of the original. To reproduce the original image, you must now retrace the tracing. This second image will be like the original when applied to the skin.

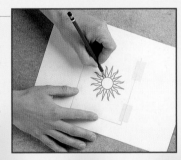

1 Place the tracing paper over the design you wish to copy and tape it in place. Trace the design carefully, making thin lines.

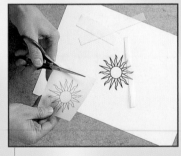

3 Cut around the tracing quite close to the edge of the design. This will make it easier to handle when applying to the skin.

SUPPLIES
- drawing or photocopy of the design
- tracing paper
- adhesive tape
- soft lead pencil (B or 2B)

Making a Stencil

The self-adhesive stencil has the advantage of giving you an exact reproduction of a design, so long as it is one that lends itself to this treatment. As you can see in the pages at the back of this book, a design must consist of various parts that are disconnected from each other to work as a stencil. However, a stencil of this kind can only be used once. If you want to use it again, make it instead from flexible cardboard. The same method is used for both types of stencil. (For application, see the Samurai design, page 42.) Please also note that adhesive acetate is not actually made for use on the skin and it should never be left in place for long.

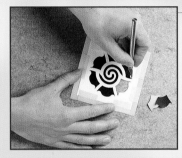

2 On a cutting board, or a piece of heavy cardboard, cut out the design, using the X-acto knife. When the cut-out is complete, detach the design from the adhesive acetate.

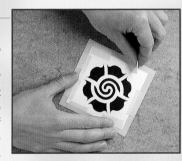

1 Center the design you want to use, leaving a ⅜ inch (1 cm) border around it. Attach it with adhesive tape to a sheet of adhesive acetate that is a little larger.

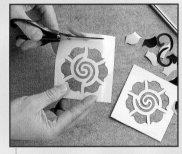

3 You will have a design cut-out, or stencil. Cut around the edge of the stencil, about ⅜ inch (1 cm) from the design. If this border is too wide, there is a chance of creasing when the stencil is applied to the skin. As you sponge on the coloring to make the tattoo, the border will also provide protection from spillover.

SUPPLIES

• drawing or photocopy of the design
• sheet of adhesive acetate or flexible cardboard
• adhesive tape
• scissors
• X-acto knife
• cutting board

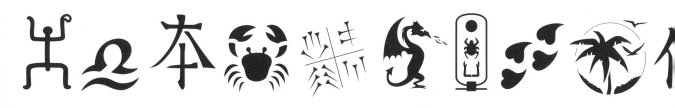

The Temporary Tattoos

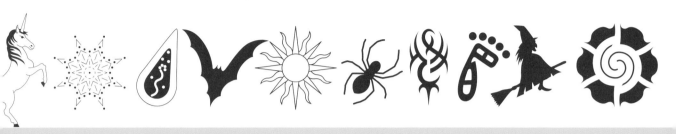

Level of Difficulty: ☆ easy ☆☆ not so easy ☆☆☆ challenging

The Sun, Source of Life ✩✩

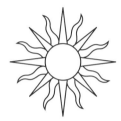

The sun is a very appropriate decoration for the navel, both in form and in its symbolic association with the life force. Indeed, it is the umbilical cord that carries nourishment from the mother to her infant. Moreover, the navel is at the center of the body. For the Japanese, the area around the navel, called *hara*, is our center of energy and equilibrium. In the Hindu faith, it is the seat of Brahma, the Creator. Start by tracing the design on page 56 onto a piece of tracing paper.

SUPPLIES
- tracing paper
- soft lead pencil
- sponge
- fine brushes (2)
- yellow body liner
- brown body liner
- red gem
- eyelash adhesive
- rubbing alcohol

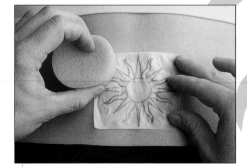

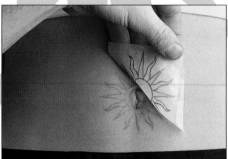

1 The model must stand upright or lie flat so that the area around the navel is flat and smooth. Moisten the skin around the navel with a sponge, apply the tracing, then lightly dampen the surface of the tracing paper with the sponge, pressing lightly with your fingertips so that the design comes off on the skin.

2 Gently peel away the tracing paper to reveal the design, ready for coloring. Now sit facing the model, with your eyes level with the navel. Place within easy reach the two fine brushes and the yellow and brown body liners.

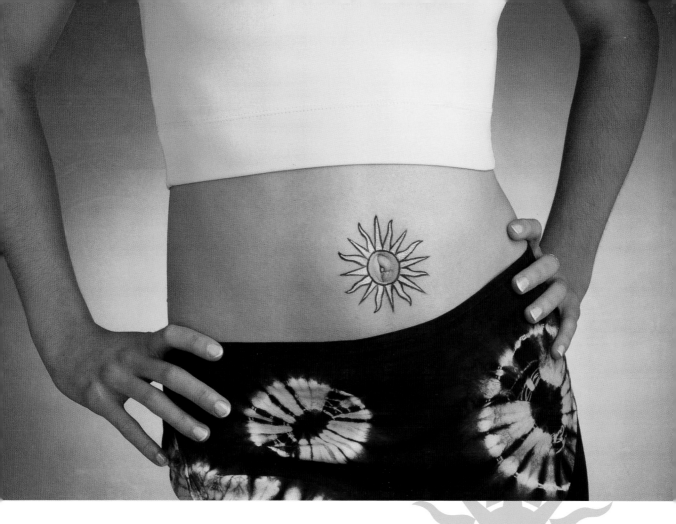

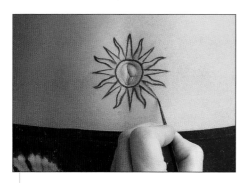

3 Using a brush and the brown liner, trace the rays of the sun—the top half first—from their tips to the center. Use a single stroke for each line. For the rays in the bottom half, start at the center and finish at the tips. Finish by painting the round central sun, using short strokes.

4 Let the design dry well before applying the interior color. Then, using the other fine brush, paint the interior of the sun's rays with the yellow body liner. If the navel will accommodate a tiny gem, this can be affixed with eyelash adhesive.

TIP:

For more stability with the brush when painting, use your small finger as a pivot on the model's skin, while your thumb and fore-finger work with the brush.

Nature

Paradise Island ★★★

SUPPLIES
- photocopy of the design
- sheet of adhesive acetate
- X-acto knife
- scissors
- adhesive tape
- sponge
- fine brush
- black body liner
- liquid watercolors made for skin in yellow, orange and blue

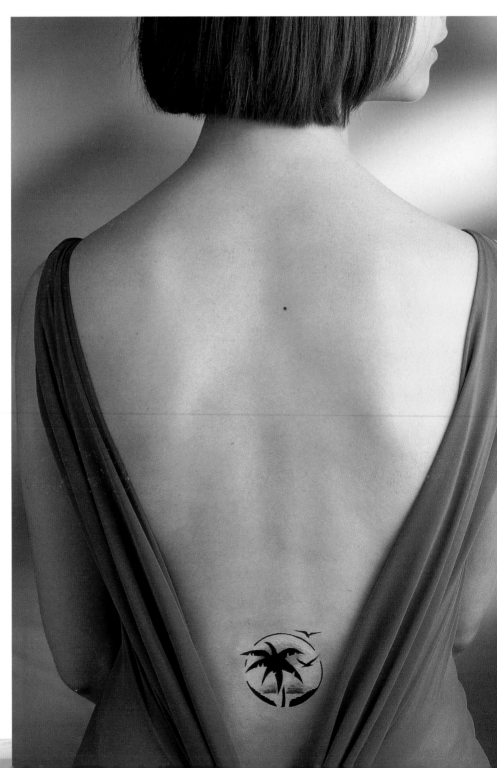

The island is a decorative motif that represents the world in microcosm. It evokes a refuge, a haven of peace, far from the cares of daily life. As part of paradise, it is synonymous with beauty and purity. Make a photocopy of the design on page 57 and then make your stencil by following the steps described on page 11.

1 Situated here in the small of the back, the island design is on the axis of the spine. Your friend should sit very straight, back to you. After choosing the best positioning for the stencil, remove the protective film and stick it in place on the skin.

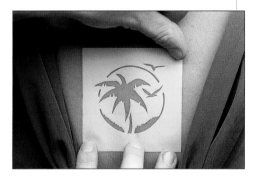

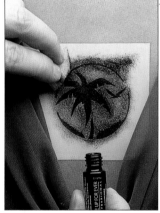

2 Cut a small piece of sponge, about 1 inch (2 cm) thick, and moisten it with enough black liner to make a good dark imprint. Daub over the stencil opening to cover the skin evenly. Allow to dry before removing the stencil and proceeding to color in the design.

3 Using a fine brush, color the sky inside the upper part of the medallion shape with the yellow liquid watercolor. Then take the orange color and fill in hints of the sun behind the palm tree, blending it carefully into the yellow sky. Finally, apply a touch of blue for the sea.

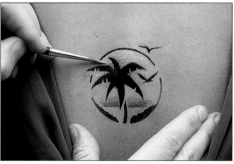

SUGGESTION:

You may decide not to add color to this design, but to use the black stencil motif alone—or to use a color for the motif that will complement your outfit.

Leaf Bracelet ☆☆

For this wrist ornament, we've combined stamp and paintbrush techniques. The leaf design, shown on page 57, was inspired by the heart shape—a symbol that is cherished by little girls.

SUPPLIES

- photocopy of the design
- foam-board
- X-acto knife
- scissors
- paper glue
- cotton swab
- yellow ocher, red ocher and maroon liners
- fine brush(es)
- rubbing alcohol

TIP: For a good finish to the design, apply the first motif on the inside of the wrist, where a bracelet clasp would go; this will camouflage any uneven matching that may occur between the first and the last of the leaves in the design. To guide your hand and keep the motifs aligned, put a rubber band around your model's wrist.

1 Choose harmonizing leaf colors: either two different ones, or two shades of the same color. Using a brush, color the leaves on the stamp. Saturate the surface with uniform color.

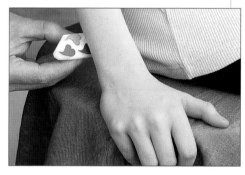

2 Apply the stamp with a rocking motion to stamp each leaf clearly, as if with a roller. The imprint should be made in one application to avoid overlapping images. Resoak the stamp with color before each application and take care to space the leaves evenly.

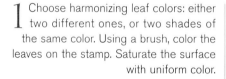

3 Once you have completed stamping the leaf design, let it dry thoroughly. Next, you are going to draw the wavy line between the leaves, using a fine brush and maroon-colored liner. You may want to practice first on a sheet of paper or your own wrist, to get a feel for this application.

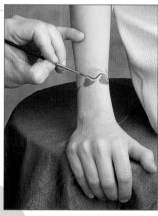

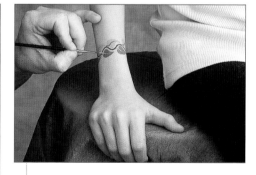

4 Now all you have to do is paint on the tiny stems that join the leaves to the central branch. Use a dark color—the maroon—on the light-colored leaves for contrast, and a pale color—the yellow ocher —on the darker leaves. This decoration can also be used on the upper arm or the ankle.

Dragon, Symbol of Divine Power ☆

SUPPLIES

• photocopy of the design
• sheet of adhesive acetate
• sponge
• scissors
• X-acto knife
• adhesive tape
• black body liner
• rubbing alcohol

The dragon is a creature of legend, a complex symbol that, in various guises (sometimes associated with destructive forces, sometimes the guardian of hidden treasures), represents the creative power of the universe. As such, it can be regarded as a good omen. Make your dragon stencil from the design shown on page 55, following the method outlined on page 11.

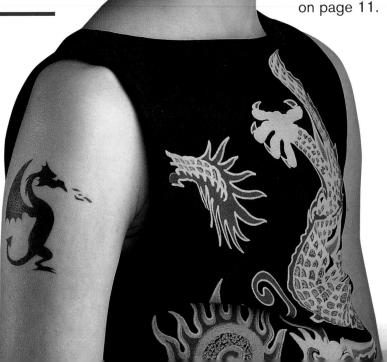

TIP: This design has been stylized to make its stencil easier to cut. You may want to add more flames along the back and tail, using a fine brush.

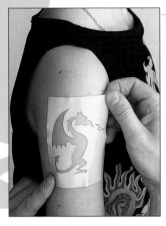

1 The model should be seated sideways, with upper arm straight and hand resting on the thigh to keep the arm steady. Swab the area where you are going to place the stencil with rubbing alcohol so that the body liner, when applied, will adhere better. Let the area dry completely and then apply the stencil.

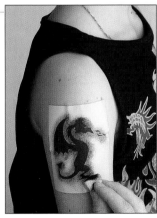

3 Carefully peel off the stencil. Wait a little longer, then gently test the black surface with a fingertip to be sure it is thoroughly dry. If any color has overflowed the edges of the design, clean this off very carefully using a cotton swab dipped in the rubbing alcohol.

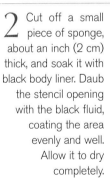

2 Cut off a small piece of sponge, about an inch (2 cm) thick, and soak it with black body liner. Daub the stencil opening with the black fluid, coating the area evenly and well. Allow it to dry completely.

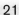

Star of Maghreb ✩✩

Henna has been used traditionally to create an infinite number of motifs: geometrical designs inspired by nature, in the Islamic tradition; a vast range of decorations with origins in the animal and vegetable kingdoms, as well as figurative designs that relate to certain rituals—all in the Hindu tradition. From such a panoply of designs, one can choose at will, according to mood and taste. The star design of the tattoo presented here is inspired by the cross, a universal symbol that occurs in all civilizations in a great variety of styles.

SUPPLIES

- pattern for the design
- a fine brush
- maroon body liner
- rubbing alcohol

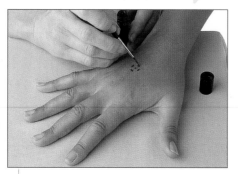

1 Have the model sit in a comfortable position, with the hand resting flat, thumb and fingers spread out as in the photograph. The design consists of a combination of dots and short lines, and you should start by drawing four tiny lines in the form of a cross around a central dot, as illustrated.

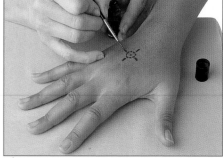

2 Now carefully paint a circle inside these four lines, as shown. To keep the paint strokes very fine, make sure you don't put too much liquid on the brush at any time.

SUGGESTION: Before starting to paint this design, make a few simple sketches on paper, using pencil or paintbrush, to familiarize yourself with the technique. Have fun creating a new design that starts, like this one, from a central point.

3 Now add four more lines, evenly spaced, around the circle. Note that the cross is the basis for the design, which will radiate progressively outward. It is important to concentrate on drawing the perpendicular lines since all the components of the design are based on them.

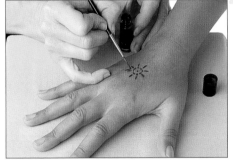

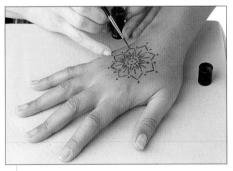

4 As you go on, follow the pattern shown on page 59 very closely: make right angles that point down between the original eight short lines, as shown. Above them, paint matching right angles, and you'll have created an eight-pointed star. Concentrate on the pattern until the design is finished.

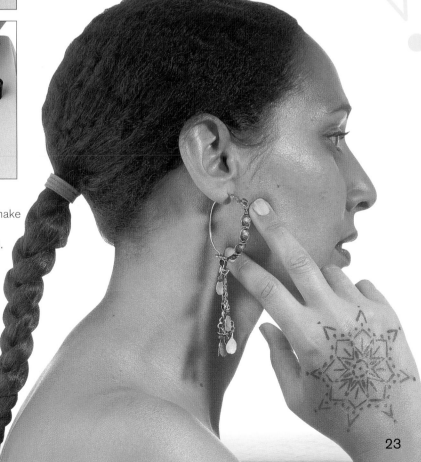

Hindu Jewelry ✰

SUPPLIES
- a bindi
- 6 red and 4 white gems
- eyelash adhesive
- orange stick for applying adhesive
- tweezers
- fine paintbrush
- gold body liner

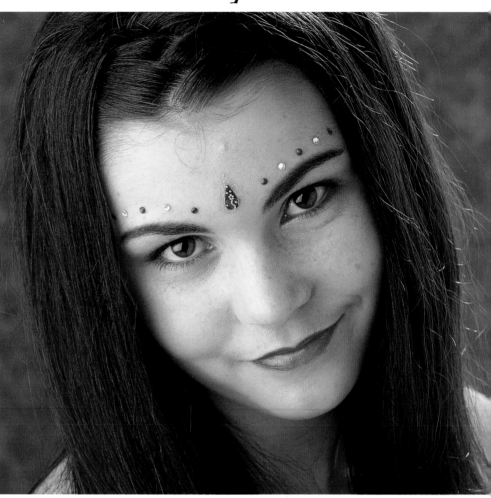

This skin decoration comes to us from India. A Hindu custom for women, along with its ornamental value, it proclaims the status of the wearer: a red dot, for example, means that a woman is married.

Many different types of decoration can be applied to the center of the forehead: a shell, a pebble, a gem; even a few sequins applied with a fingertip, or simply a bindi, as we've used here—and there are many varieties of these.

TIP: Apply the adhesive with the tip of an orange stick, so that a minimum amount is used, and stick the gems and bindi on with your fingertip or a pair of tweezers. If using very small gemstones, have the model hold a towel to catch any that you may drop.

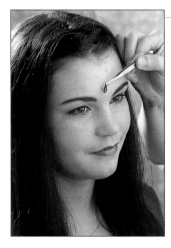

1 Most bindis that are sold commercially are self-adhesive (but if not, use the false-eyelash glue, as for the gemstones; this glue has a latex base and can be removed without using a solvent). Using tweezers, apply the bindi to the center of the forehead, above the line of the eyebrows, and in line with the bridge of the nose.

3 Stick a red-colored gem at each end of the eyebrow, and then place a third in between them. Be sure that the level of the gems is identical for each brow. Finally, stick the white gemstones in between the red ones above each eyebrow, as shown on the previous page.

2 Using a fine brush and gold liner, paint a narrow gold line around the bindi to make it look even brighter and more glamorous. To position the gemstones evenly and complete this facial decoration, you should follow the line of the eyebrows.

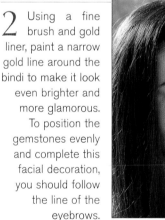
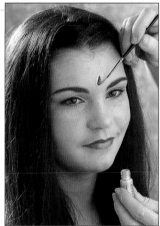

Indonesian Spiral ★★★

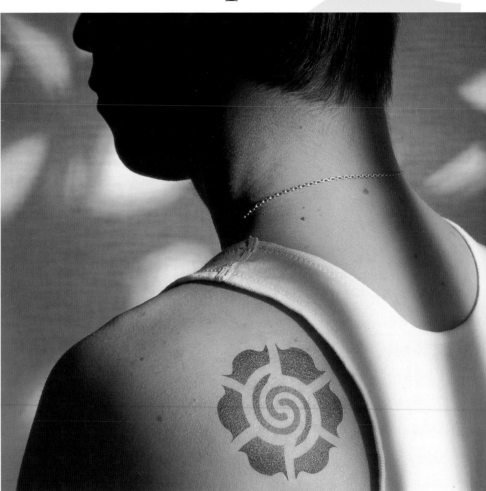

SUPPLIES
- photocopy of the design
- sheet of adhesive acetate
- scissors
- X-acto knife
- 3 sponges
- red-ocher, maroon and black body liners
- adhesive tape
- rubbing alcohol

The spiral is a universal motif. We find it in the vegetable world (ferns) and that of the animal kingdom (snails, for instance). Among other things, it symbolizes the cyclical nature of evolution. The double spiral stands for the duality of evolution and involution. It represents the alternation and the balance of the cosmic properties yin and yang. The spiral shown here was inspired by a traditional design of the Dayak tribe of Borneo.

To make a stencil of this design, refer to the illustration on page 58.

TIP: To achieve the desired color nuances, proceed slowly, applying just the right amount of liquid at each stage. The finished tattoo should have the same color shadings as those shown in the photograph on the preceding page.

2 Moisten a small piece of sponge about 1 inch (2 cm) thick with several drops of the red ocher liner and daub the center of the design. With a lighter touch, gently blur the color around the edges.

1 After cleaning the skin with rubbing alcohol in the area of application and letting it dry completely, affix the stencil to the shoulder-blade. The three colors you will be using are red ocher, maroon and black, shades that will bring to life the movement associated with the spiral.

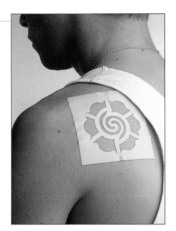

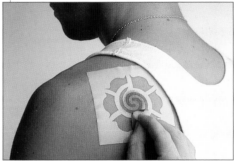

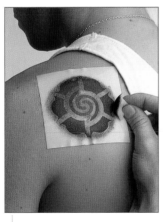

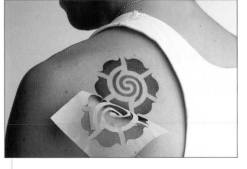

4 Use the same method to apply the black liner around the outer edges of the stencil. Let it dry well before removing the stencil.

3 Take a second piece of sponge and with it apply the maroon-colored liner around the central part of the stencil, using a circular motion. Lightly blend the maroon into the red-ocher edges of color.

Toltec Divine Footprint ☆☆

The design is inspired by a motif that originated with the Toltecs in ancient Mexico and represents the footprint of the divine. With this design, the colors of the clothing to be worn as well as of the individual's skin will dictate the shades chosen for the tattoos. Iridescent and metallic liners will look particularly attractive on dark or golden skins.

SUPPLIES

- photocopy of the design
- foam-board
- scissors
- X-acto knife
- paper glue
- cotton pads
- 3 sponges
- silver, green and maroon body liners
- rubbing alcohol

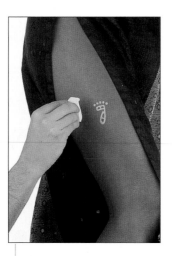

1 For easiest application of the tattoos, you must have the model stand upright. Start with the lightest color, silver, as the center tattoo. Use one of the sponges to moisten the stamp surface with the liner and immediately apply it to the skin, as metallic fluids dry very rapidly.

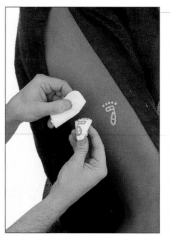

2 Soak a cotton pad with rubbing alcohol and use it to clean the stamp so that you can work with the next color. Clean the stamp each time you change the color and once you have finished all the tattoos, so that you can use it again. And use a fresh piece of sponge for applying each of the colors to the stamp.

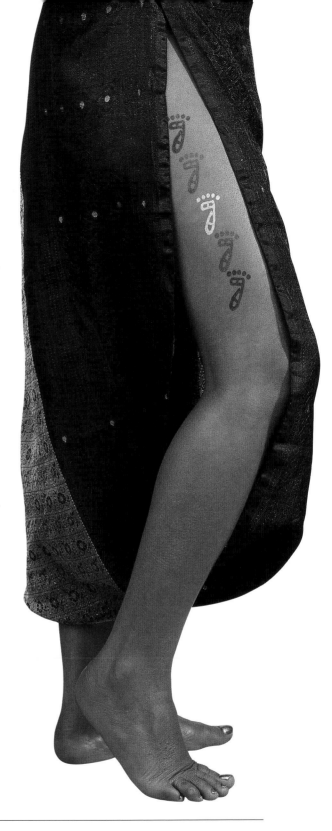

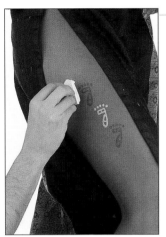

3 On either side of the silver tattoo, apply a green one. Reapply green liner to the stamp surface for each of these applications. No matter how you position this design, it is important to apply each tattoo at the same angle and to keep an equal space between them all.

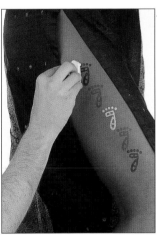

4 Finish your work with the darkest color, the maroon. Obviously, when you apply a row of tattoos such as this to the thigh, the top one should align with the opening of the garment.

TIP: Some designs are particularly suitable for the thigh. For example, the bamboo on page 56, or a row of Chinese or Japanese characters (pages 59 and 60), can convey your subtle message.

Tribal Inspiration ⭐⭐

Such motifs are prized as tattoos. They have inspired an infinite number of abstract designs, interlacing arabesques that enhance the fullness of the body. Use the design on page 58 for your stencil.

SUPPLIES

- photocopy of the design
- sheet of adhesive acetate
- scissors
- X-acto knife
- sponge
- iridescent plum-colored body liner
- adhesive tape
- cotton swabs
- rubbing alcohol

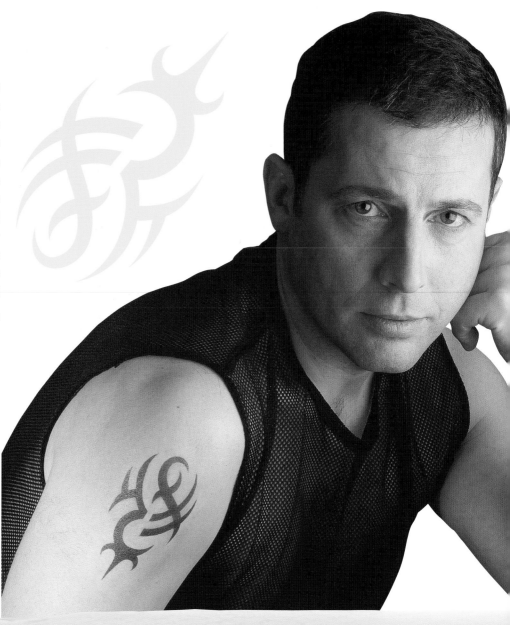

SUGGESTION: This design demands precision, from cutting the stencil to separating the acetate and its protective backing, right up to the moment of application to the skin.

1 It is advisable to position the stencil carefully to see how it will look before actually applying it to the skin. Once this has been established, carefully fix it in place.

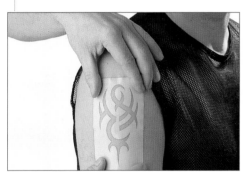

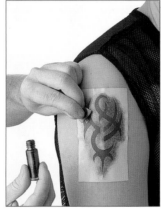

2 Moisten a small piece of sponge with the iridescent plum-colored liner, then daub the stencil opening, working from the center outward, covering the skin evenly. One application should provide sufficiently intense color.

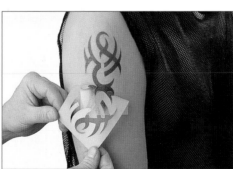

3 Let it dry for a few minutes before carefully peeling off the acetate. Test the color with your fingertip to be sure it is completely dry. If any color has overflowed the edges of the design, clean this off very carefully using a cotton swab dipped in the rubbing alcohol.

STENCIL TECHNIQUE

Cancer the Crab ✩✩

To depict the astrological theme of Cancer, we offer you a stardust cocktail: the design on page 62 is enhanced here with a few brushstrokes and highlighted with gemstones and hologram embossing powder.

SUPPLIES

- photocopy of the design
- sheet of adhesive acetate
- scissors
- X-acto knife
- adhesive tape
- sponge
- fine brush
- gold body liner
- orange stick for applying adhesive
- eyelash adhesive
- tweezers
- hologram embossing powder or glittery powder
- rubbing alcohol

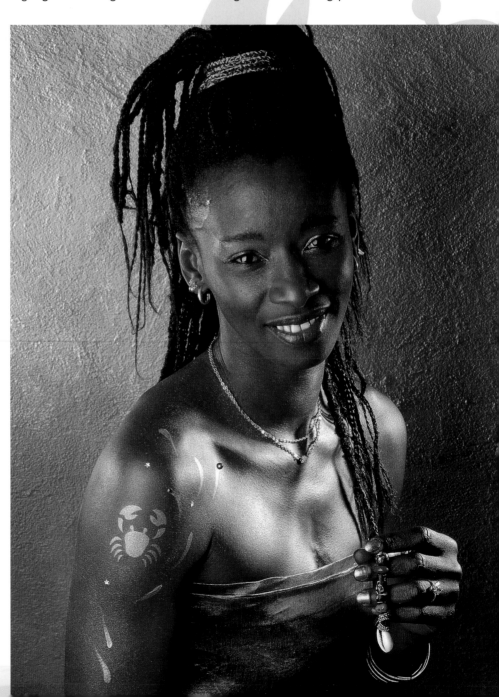

1 The model should be seated sideways, with upper arm straight and hand resting on the thigh to keep the arm steady. First, determine the position of the tattoo by holding the stencil against the upper arm. Clean the skin area with rubbing alcohol. Peel away the backing from the adhesive side of the stencil.

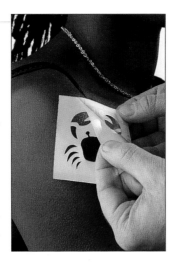

2 Affix the stencil to the skin. Cut out a small piece of sponge about 1 inch (2 cm) thick and moisten it with a few drops of the gold liner. Daub the color uniformly over the stencil opening. Let the color dry, then carefully peel away the adhesive.

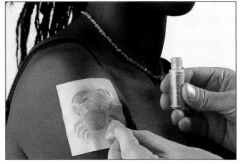

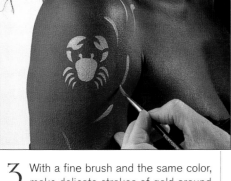

3 With a fine brush and the same color, make delicate strokes of gold around the astrological symbol. Make each a single stroke, taking a little more liner each time. Let this color dry.

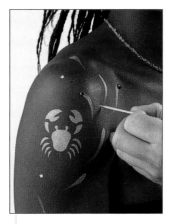

4 Decide where you want to place the tiny colored gemstones. To fix them to the skin, apply a drop of eyelash adhesive to the back of each, either directly from the tube or with an orange stick, and apply them using your fingertips or the tweezers.

TIP: To further enhance this cosmic delight, use a fine brush to apply gold iridescent body gel or glittery powder around the design.

Tree of Life ☆

The tree symbolizes constant regeneration. In the Garden of Eden, fruit from the tree of life bestowed immortality, its sap the dew of heaven. For this bracelet, we've used a commercial stamp in combination with three inking pads, in maroon, black and midnight blue.

SUPPLIES
• tree of life
(or similar) stamp
• 3 inking pads:
maroon, black and
midnight blue
• rubber band
• cotton pads
• rubbing alcohol

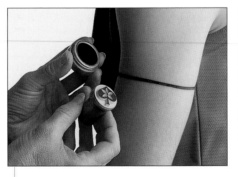

1 As a guide for keeping the pattern aligned, put a rubber band around your model's arm, just above the position chosen for the bracelet. Alternatively, use the kind of adhesive tape that is easy to apply and to remove.

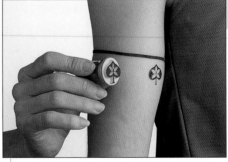

2 For temporary tattoos, it is preferable to leave the inner arm bare, since it is anyway subject to the friction of clothing and to perspiration. Press the stamp lightly onto the ink pad so that color adheres only to the raised part of the design, then apply it firmly to the skin.

3 Clean the stamp surface with a cotton pad dipped in rubbing alcohol each time you want to change the color you are using. When you have completed the bracelet, thoroughly clean the stamp again so that it can be reused.

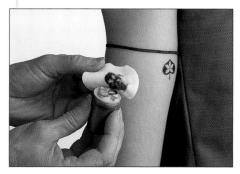

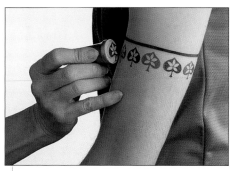

4 Apply the colors one after the other, keeping even spaces between each of the motifs. Mark the vertical line on the back of the stamp, so that the angle of each imprint will be identical.

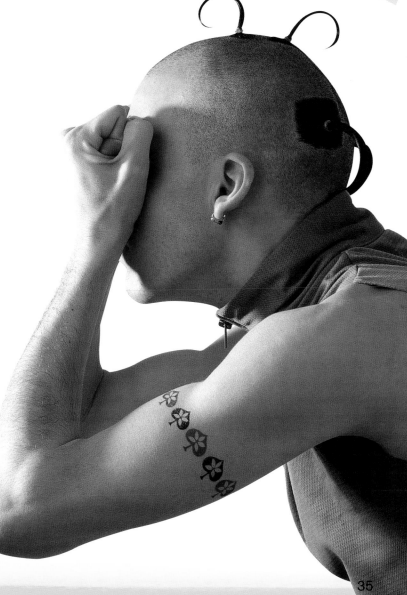

Astro Symbols

Unicorn of Protection ✩✩✩

SUPPLIES
- tracing paper
- lead pencil (B)
- sponge
- black, maroon and yellow ocher body liners
- fine paintbrush

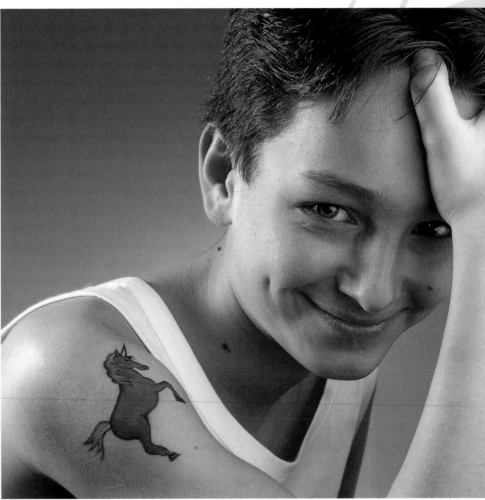

Since the very earliest times, people have decorated their skin with symbolic images to attract the virtues that they evoke. The unicorn, with its single horn in the middle of its forehead, representing both a ray of sunlight and the sword of God, symbolizes spiritual fertility. It is also connected to the concept of integrity. In medieval times and in ancient China, it symbolized power and purity. The unicorn design is on page 55.

1 Trace the unicorn design on page 55 with a lead pencil. Remember that you need to retrace the reverse of the first tracing if you want to reproduce the drawing exactly. Moisten the skin with a sponge, then apply the tracing paper to it and, with the same sponge, moisten the outside of the paper. Smooth your fingers firmly over the design to leave its imprint on the skin. Carefully remove the tracing paper.

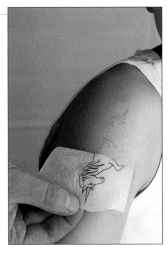

2 When the skin has dried, trace the outlines of the design with a fine brush dipped in black liner. Start the painting at the top of the motif, finishing at the base. Avoid touching the imprint of the design with your fingers, as it will come off.

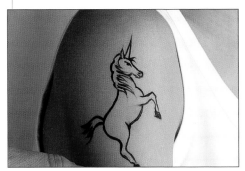

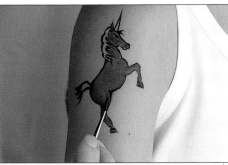

3 With the maroon liner, color the inner part of the design—the unicorn's coat —taking care not to go over the borders. Always use undiluted colors to preserve their bright tones and their drying and lasting properties. In this way, one coating of color will be enough.

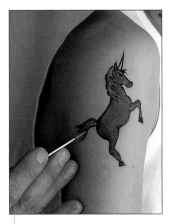

4 Finally, using the yellow ocher liner, color in the mane and the tail. If the outline has blurred at all, trace it again with black liner, taking care to keep the lines as narrow as they were originally.

TIP: You may prefer not to color the inside of the unicorn at all. In this case, you should be extra careful when painting its outline.

Prayer Necklace ⋆⋆

This design of a human silhouette was inspired by one that dates from the Bronze Age, which was found in Lombardy in northern Italy. Called *orant* (from the Latin *orare*, to pray), because the image is in a praying posture, it is a shape that is easy to make as a stamp.

Applied in a half-circle to form a necklace, this tattoo pattern will blend with other neck adornments: necklaces, chokers or chains. Its alignment must suit the neckline of the garment being worn. To avoid any overlapping of clothing or jewelry with this tattoo design, it's best to apply it with the other items in place. The design for the stamp is on page 63. See page 9 for how to make the stamp.

SUPPLIES
- photocopy of the design
- foam-board
- silver body liner
- scissors
- X-acto knife
- cotton pads
- paper glue
- eyelash adhesive
- sponge
- orange stick for applying adhesive
- tweezers
- gem stones
- rubbing alcohol

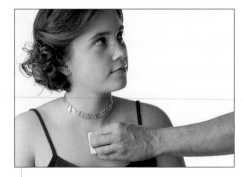
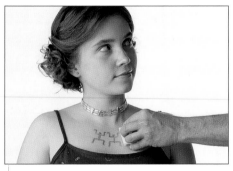

1 Cleanse the skin with a cotton pad soaked with rubbing alcohol. Let it dry. Cut out a small piece of sponge about 1 inch (2 cm) thick and place a few drops of silver body liner on it, then use the sponge to coat the stamp. Immediately apply it to the skin, making one firm impression.

2 Apply new color to the stamp before each impression. To align the motifs symmetrically, start with the middle one, then place one to the right, then one to the left, and so on. Always make one firm impression with the stamp so that each motif is clearly printed.

TIP : To ensure that these motifs form an attractive curve, position a long string or shoelace around the neckline to serve as a guide when you are using the stamp.

3 Make the motifs follow the curve of the neckline in an attractive arc. A dusting of iridescent powder along the curve will make the pattern easy to follow. Carry the designs only as far as the clavicles on each side, where the skin surface is no longer flat.

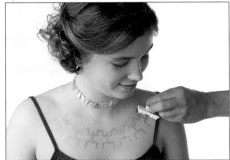

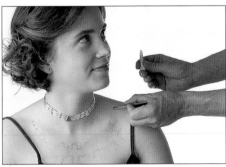

4 Complete this skin decoration with a few tiny gemstones. Dot the back of each stone with a little eyelash adhesive, using an orange stick, then apply the gems to the skin using tweezers.

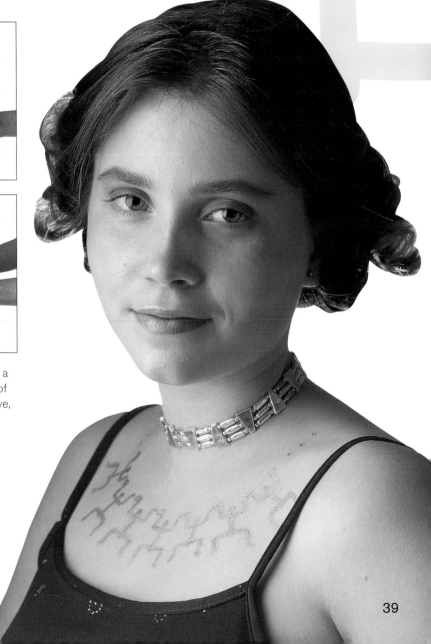

Chinese Ideogram: Prosperity ☆

T his Chinese ideogram, reproduced on page 59, means "to progress, to advance, to prosper quickly." In summer, the motif enhances bare feet or those in open-style sandals. Refer to page 9 for the stamp-making technique.

SUPPLIES

- photocopy of the design
- foam-board
- sponge
- iridescent plum-colored liner
- paper glue
- scissors
- X-acto knife
- cotton pads
- rubbing alcohol

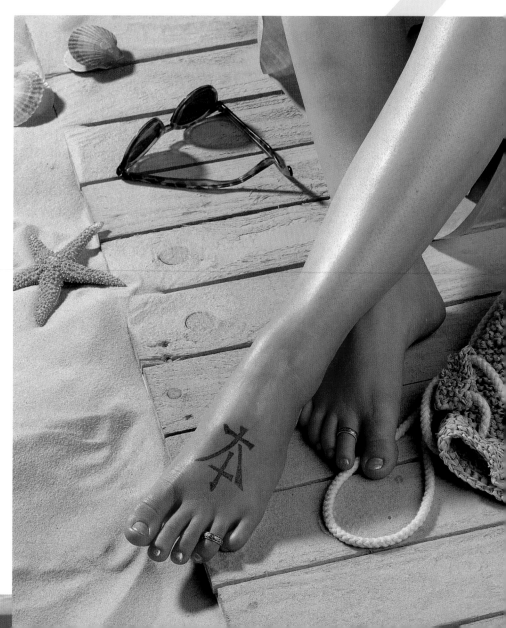

TIP: This stamp has the advantage of being reusable. During the summer, you can use it on other parts of your body and for different occasions. You can also use different colors.

2 Immediately apply the stamp to the center of the foot, as shown. Use a simple rocking motion with constant pressure on the stamp to make the impression in one pass—otherwise, you run the risk of a double image or blurred effect.

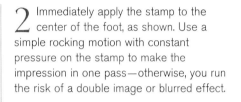

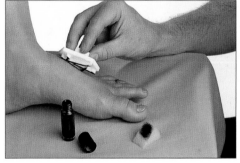

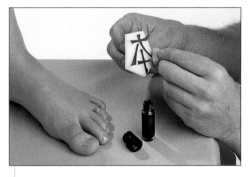

1 The model's foot should be stretched out as shown, offering a flat surface for stamping the design. Cut out a small piece of sponge about 1 inch (2 cm) thick and place a few drops of the iridescent plum-colored liner on it, using this to coat the stamp's design.

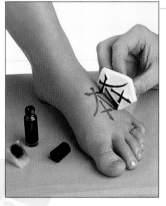

3 This photo shows clearly that the image on the stamp is the reverse of that "tattooed" on the foot. It is important to remember this when making a stamp. After use, clean the stamp thoroughly with rubbing alcohol so you can use it again.

Japanese Character: Samurai ☆

In the words of a Chinese calligrapher: "The line connects the heartbeat of a person to the heartbeat of the world."

This tattoo design, reproduced on page 60, represents the Japanese character for samurai, an individual who stands for bravery and loyalty.

SUPPLIES

- photocopy of the design
- flexible cardboard
- transparent tape (hypoallergenic clear first aid tape works best)
- adhesive tape
- white makeup pencil
- white body liner with applicator or eyeliner brush
- cotton pads
- rubbing alcohol

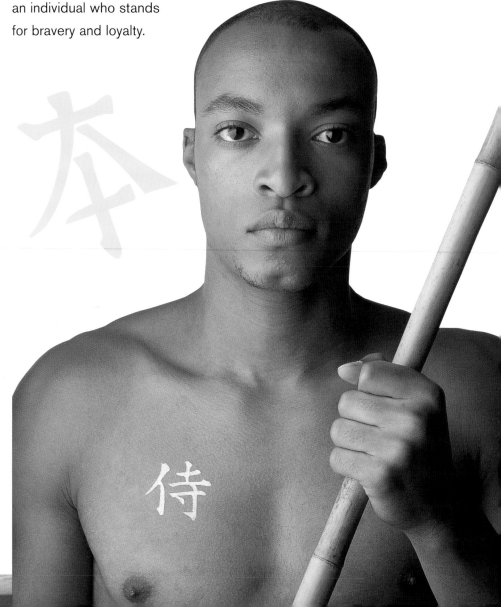

TIP: To make the stencil, we've used a light flexible cardboard: it must be supple enough to conform to the surface on which it is being placed, while keeping stiff enough that it won't crease or tear easily. A stencil of this type can be used several times.

1 Cleanse the skin where the tattoo is to be placed with a cotton pad soaked in rubbing alcohol. When the skin is dry, attach the stencil with transparent tape, as shown, fastening down all four sides.

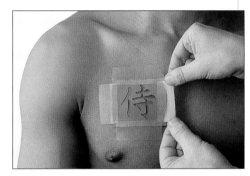

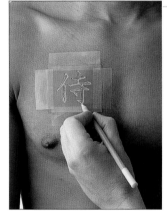

2 With a well-sharpened white makeup pencil, trace the outlines of the character. Do this with great precision, sharpening the pencil as necessary to maintain a fine, clear line.

3 Gently peel off the tape with the stencil still attached. Save the stencil for future use, after removing the tape.

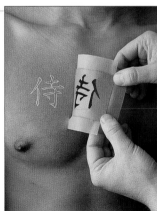

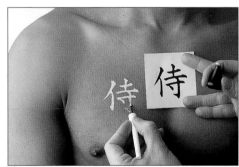

4 Fill in the outlines with white body liner, which may have its own applicator brush. If not, you can use an eyeliner brush, the perfect tool for this precision work.

Sumerian Cuneiform Designs ★★★

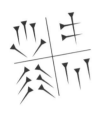

SUPPLIES
• chisel brush
• maroon-red
body liner
• shells
(we used cowries)
• eyelash adhesive
• orange stick for
applying adhesive

These decorative motifs are inspired by the cuneiform script of the Sumerians, dating back some five thousand years. (Cuneiform means "wedge-shaped.") The cuneiform script was cut into tablets of clay with beveled reeds called *calames*. These symbols lend themselves to any number of design combinations. We offer a few here, which you will find reproduced on page 59.

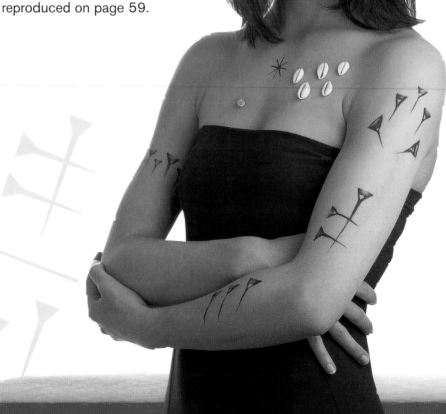

TIP: Using the chisel brush and some body liner or similar fluid, practice making this design on your own forearm or on a sheet of paper. You should be able to make each symbol with only three brushstrokes.

1 A chisel paintbrush is perfect for cuneiform script. Dip it in the maroon red body liner and paint the first symbol in the center of the upper arm, as shown in the photograph.

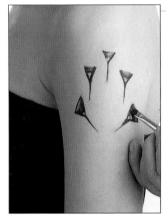

2 The model's arm should be held perfectly straight as you paint in the other symbols, two straight ones on either side of the first, then two obliquely situated below them. On the forearm, cross three symbols as shown in the middle grouping, then paint them horizontally and parallel to each other. The model's right arm is decorated with a "bracelet" of these symbols alternating in height.

3 Carefully paint a star at the neck-line, then paint three symbols on the left cheekbone, just below the eye to emphasize it, as in the photo.

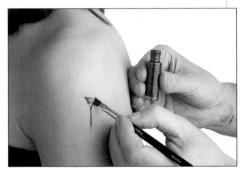

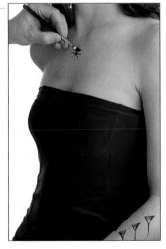

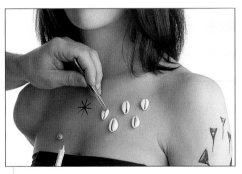

4 To complement the earth colors of the cuneiform script, apply a few shells to the skin as we have done. Place a few drops of eyelash adhesive on the skin to hold the shells in place, then apply the cowries with tweezers, lightly pressing each into place with your finger and holding for a moment.

Egyptian Cartouche ★★

SUPPLIES
- tracing paper
- soft lead pencil
- sponge
- body liners in yellow ocher, red ocher, iridescent green and black
- fine brush
- cotton swabs
- rubbing alcohol

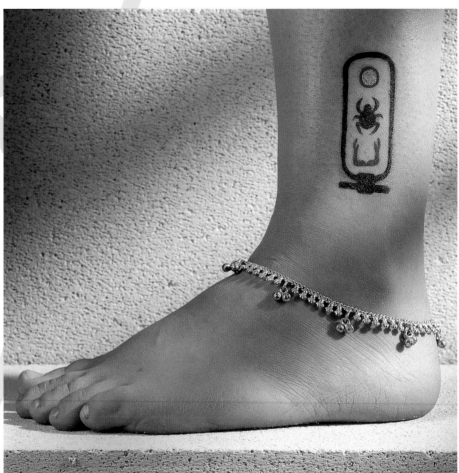

Traditionally, the border of this cartouche was formed by a rope knotted at the bottom to signify "what the sun encircles." To show that the world belonged to the Pharaoh, his personal cartouche contained the two most important of his five names.

To achieve good results with this delicate imagery (see page 60), we suggest you refer again to page 10 for the method of tracing a design for painting.

TIP: When using liquid colors, never take too much at a time onto the tip of your brush; this way, you will avoid runs or spoiling fine edges. For best results, always trace the design from top to bottom.

1 The model should be seated, with foot flat on a stool or bench and leg held straight for application of the design. Moisten the skin before applying the tracing, pencil side inward. Carefully smooth over the tracing with a damp sponge, then press the design gently with your fingertips to help transfer the image to the skin.

2 Peel back one corner of the tracing paper at first, to ensure that the image has been imprinted on the skin (if not, press around it again with your fingertips). When it is satisfactory, remove the tracing paper completely. Wait until the skin has dried thoroughly before moving on to the next step.

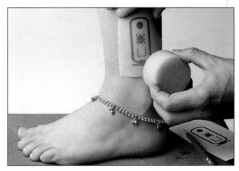

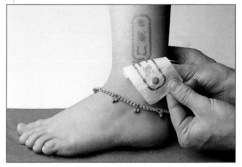

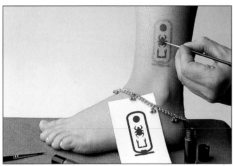

3 Take care to have a solid working position, with your eyes at the same level as the image you are about to paint on. First, color the motifs inside the cartouche, using a fine brush dipped in the liner: red ocher for two of the motifs, and iridescent green for the scarab. Add a touch of yellow ocher to the top motif, which represents the sun.

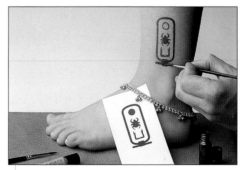

4 Now fill in the rope border of the cartouche with the black liner. Use an eyeliner brush: its short, dense tip works well with this precision painting. If the color happens to run over the edges at all, clean the overflow very carefully with a cotton swab soaked in rubbing alcohol.

Spider's Spell ✮✮✮

Halloween—what a perfect time to use temporary tattoos! And it really lasts all night—until the supernatural creatures of the invisible world, now satiated, return to their astral realm at dawn. With makeup and costume complemented by a spooky spider tattoo, you'll be all set to confront the ghosts and goblins! The design is on page 64.

SUPPLIES

- photocopy of the design
- foam-board
- black body liner
- sponge
- fine paintbrush
- scissors
- X-acto knife
- paper glue
- cotton swabs
- rubbing alcohol

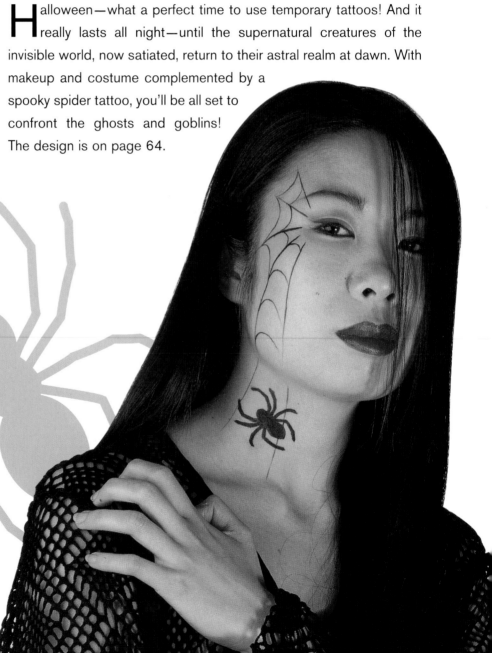

TIP: To draw a long straight line with a single stroke, use a fine artist's brush with a rather long tip to retain as much liquid as possible. With a steady hand, concentrate just on the line. It will help to place the tip of your small finger on the model's cheek as a kind of pivot. As with other designs, you may wish to experiment first by drawing similar lines on your own forearm before starting to paint them on the model's face.

1 For the application of the spider tattoo, the model's head should be held up straight, neck positioned so that the skin is flat where the stamp is to be applied. Determine exactly where you wish to put the spider.

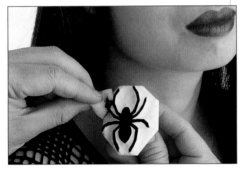

2 Cut out a small piece of sponge about 1 inch (2 cm) thick and moisten it with a few drops of the black liner. Use this to color the spider motif on the stamp and apply it at once to the neck, using a gentle right-to-left rocking motion, so that one pass completes the imprint.

3 With a fine brush dipped in the black liner, start to draw the spider's web about half an inch (1 cm) from the outer corner of the model's eye, as shown in the photo. The lines of the web at the top should fan out from the eye toward the hairline. When painting these lines, be sure that you do not hold the brush too tightly.

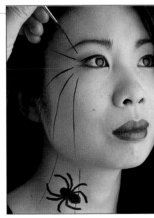

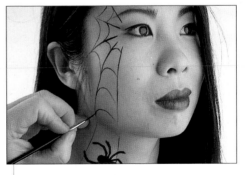

4 Now paint in the curved threads of the web, from top to bottom, as shown. A single stroke of the brush should be used for these arced lines. The finished effect should be one of lightness.

Witch ☆

F ar from the ancient pagan rites that honored the souls of the dead— guardians of the living—our contemporary Halloween has taken a new symbol: the witch. Here she is: powerful, dangerous, associated with dark and unmentionable thoughts. Trace the design on page 64 to reproduce her image.

SUPPLIES

• tracing paper
• soft lead pencil
• sponge
• black body liner
• fine brush
• gemstones
• eyelash adhesive
• orange stick for applying adhesive
• tweezers
• cotton swabs
• rubbing alcohol

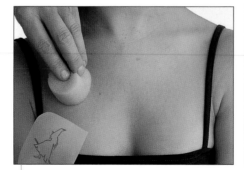

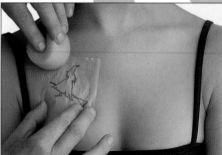

1 The model should be seated. After tracing the outline of the witch with a soft lead pencil, position the paper against the skin, as shown in the photo, to determine the best placing for the tattoo. Moisten the skin in that area and press the traced design onto it.

2 Hold the tracing paper in position with one hand while you pass a damp sponge over it to transfer the pencil image to the skin. Now press your fingertips all around the image to be sure that it has been imprinted on the skin.

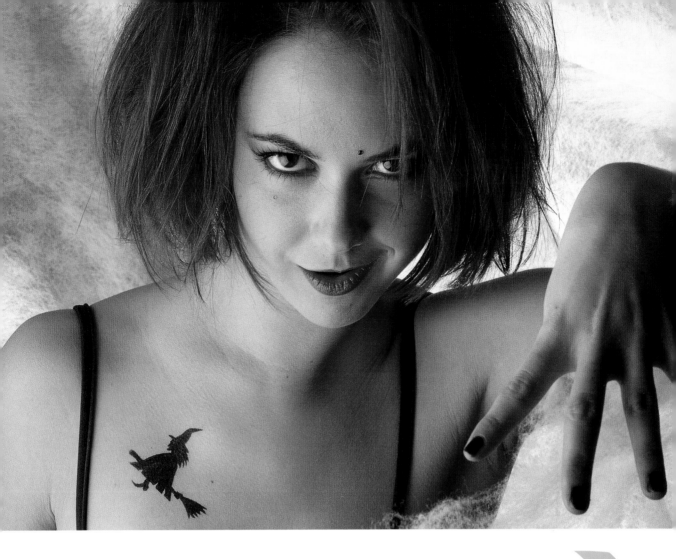

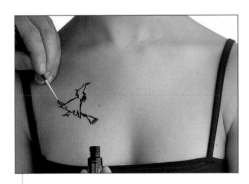

3 With a fine brush dipped in black liner, trace the outline of the design. Do not touch the penciled outline with your fingers or it will rub off. Any errors in the painted outline can be carefully removed with a cotton swab soaked in rubbing alcohol.

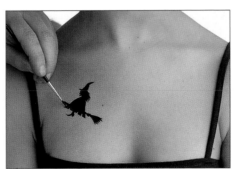

4 Now fill in the design with the black liner, taking care not to use too much at a time. A thin coating will adhere best to the skin. Again, clean any overflow carefully with an alcohol-soaked cotton swab. After a few moments, use your fingertip to check that the color is dry.

TIP: Thanks to this malevolent-looking tattoo, you're now all ready to celebrate Halloween. You may also want to stick a few green or purple gemstones on your face (see photo above) to look like warts.

Halloween

Bat ☆

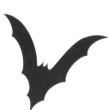

While it is a symbol of happiness in the Far East, in the West the bat is most often associated with the forces of darkness. It is one of the traditional symbols of Halloween. This bat tattoo completes the vampire makeup here, and you will find the design for it on page 64.

SUPPLIES
- photocopy of the design
- sheet of adhesive acetate
- adhesive tape
- black body liner
- scissors
- X-acto knife
- sponge
- small gemstones
- orange stick for applying adhesive
- eyelash adhesive
- tweezers
- cotton swabs
- rubbing alcohol

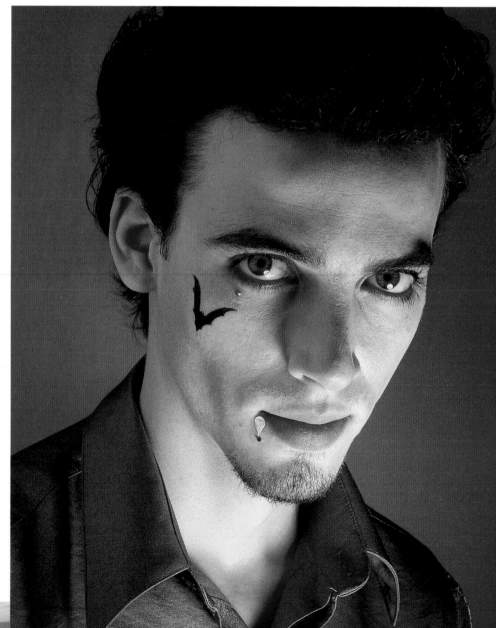

TIP: We advise using only eyelash adhesive for applying gemstones to the skin: it dries very quickly and, having a latex base, can be removed with the fingers without using a solvent. This means you can easily reposition a gemstone without any skin irritation (unless you have an allergy to latex), if you've put it in the wrong place. Use an orange stick to dab a drop of glue onto the back of the stone, then put it in place on the skin using tweezers or your fingertips.

2 Cut out a small piece of sponge about 1 inch (2 cm) thick and moisten it with a few drops of black body liner. Daub the stencil opening so that the motif is completely and uniformly covered. Let the design dry before carefully removing the adhesive. Clean any color overflow with a cotton swab dipped in rubbing alcohol.

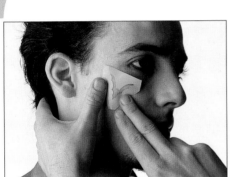

1 Since you are applying this stencil to the cheek, it will work best with as little material as possible left around the stencil opening (see photo above). First, clean the cheek area with rubbing alcohol, then let it dry.

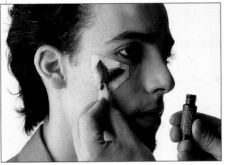

3 To enhance this design, place a few gemstones in strategic spots on the face, as shown: stick a ruby-colored gem below the lower eyelid. To the corner of the lower lip, attach a whitish gem in the shape of a fang, and a blood-colored drop at its tip.

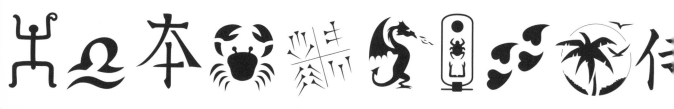

The Designs

FOR TEMPORARY TATTOOS

Numbers signify tattooing method: **(1)** Stamp **(2)** Stencil **(3)** Brush

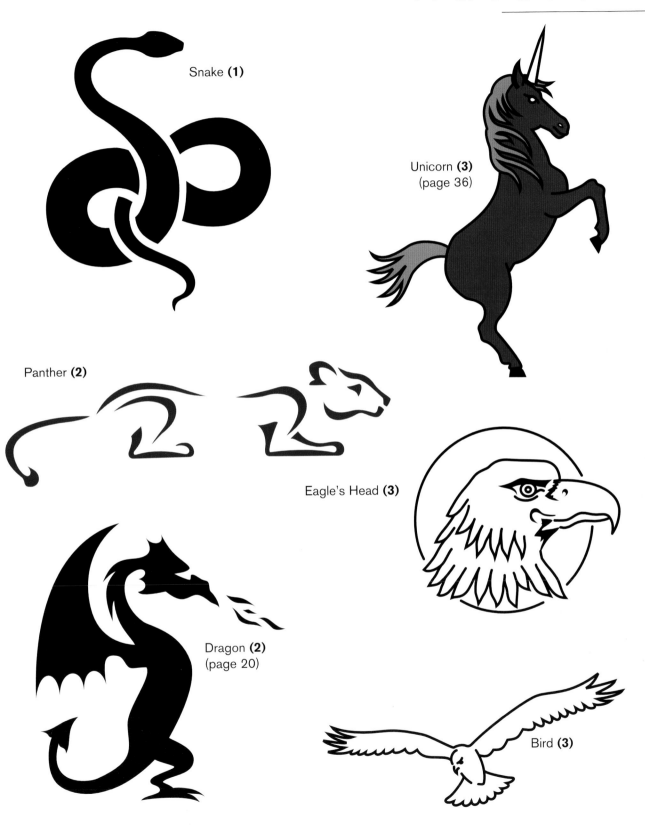

Snake **(1)**

Unicorn **(3)**
(page 36)

Panther **(2)**

Eagle's Head **(3)**

Dragon **(2)**
(page 20)

Bird **(3)**

Nature

Saturn **(1)**

Sun **(3)**
(page 14)

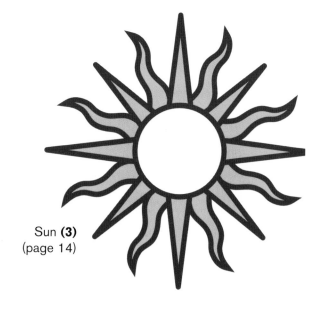

Bamboo **(2)**

Palm Trees **(2)**

Butterfly **(1)**

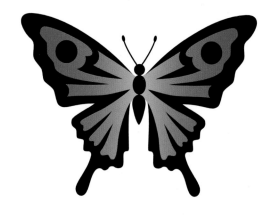

Lotus **(1)**

(1) Stamp **(2)** Stencil **(3)** Brush

Rose **(3)**

Leaf Bracelet **(1)**
(page 18)

Orchid **(3)**

Paradise Island **(2)**
(page 16)

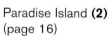

Plant Motif **(3)**

International

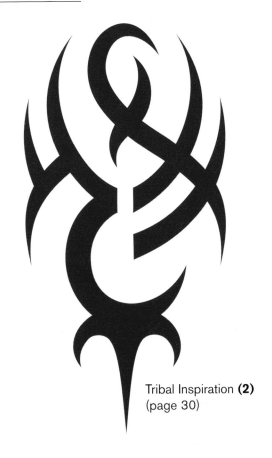

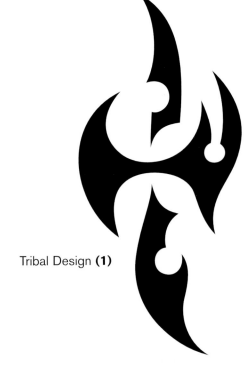

Tribal Design **(1)**

Tribal Inspiration **(2)**
(page 30)

The Morning Star **(1)**
(Ancient Mexico)

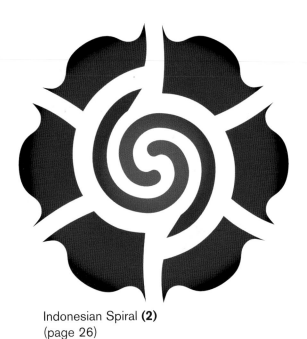

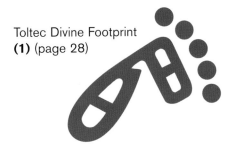

Toltec Divine Footprint
(1) (page 28)

Indonesian Spiral **(2)**
(page 26)

(1) Stamp **(2)** Stencil **(3)** Brush

Star of Maghreb **(3)**
(page 22)

Maghreb Design **(3)**

Chinese Ideogram: Prosperity **(1)**
(page 40)

Chinese Ideogram: Light **(2)**

Celtic Motif **(1)**

Sumerian Cuneiform Designs **(3)**
(page 44)

Calligraphy

Arabic: Liberty **(2)**

Arabic: Love **(2)**

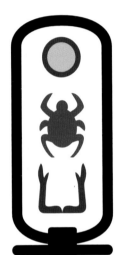

Egyptian Cartouche **(3)**
(page 46)

Eye of Horus (Egyptian Sun God) **(3)**

Japanese Characters **(3)**

Sky
Water Fire
Earth

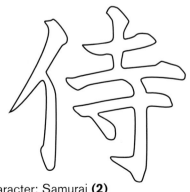

Japanese Character: Samurai **(2)**
(page 42)

(1) Stamp **(2)** Stencil **(3)** Brush

Signs of the Zodiac

Aries **(3)**

Aquarius **(3)**

Leo **(3)**

Taurus **(3)**

Scorpio **(2)**

Sagittarius **(2)**

Signs of the Zodiac

Pisces **(1)**

Gemini **(1)**

Capricorn **(2)**

Libra **(1)**

Virgo **(1)**

Cancer **(2)**
(page 32)

(1) Stamp **(2)** Stencil **(3)** Brush

Solar Disk (Bronze Age: Scandinavian) **(2)**

Hindu Symbol: OM **(2)**

Egyptian Ankh (Symbol of Life) **(1)**

Celtic Cross **(1)**

Prayer Necklace **(1)**
(page 38)

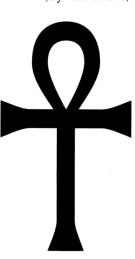

Internet Icon **(2)**

Animal Footprint **(1)**

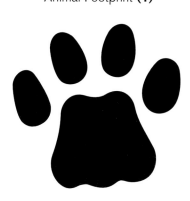

Halloween

Spider **(1)**
(page 48)

Witch **(3)**
(page 50)

Bat **(2)**
(page 52)

Devil **(3)**

Ghost **(3)**

Jack o' Lantern **(1)**

Skeleton's hand **(2)**

(1) Stamp **(2)** Stencil **(3)** Brush